Cadmium yellow lemon

Phthalocyanine blue

The

ACRYLIC PAINTER'S POCKET PALETTE

Practical visual advice on how to
create over 2000 acrylic colors
from a small basic range

Ian Sidaway

**NORTH
LIGHT
BOOKS**
Cincinnati, Ohio

A QUARTO BOOK
Copyright © 1994
Quarto Inc.
First published in the U.S.A.
by North Light Books,
an imprint of
F & W Publications, Inc,
1507 Dana Avenue,
Cincinnati, Ohio 45207
(800) 289-0963

ISBN 0-89134-581-7

Reprinted 1996

This book was designed
and produced by
Quarto Inc.
The Old Brewery
6 Blundell Street
London N7 9BH

While every care has
been taken with the
printing of the color
charts, the publishers
cannot guarantee total
accuracy in every case.

Art editor
Clare Baggaley
Copy editor
Hazel Harrison
Senior editor
Kate Kirby
Picture researcher
Laura Bangert
Editorial director
Sophie Collins
Art director
Moira Clinch

Typeset by Poole
Typesetting,
Bournemouth.
Manufactured in
Singapore by
Bright Arts Pte Ltd.
Printed in Singapore
by Star Standard
Industries (Pte) Ltd.

With special thanks to
Liquitex, whose paints
are used throughout
this book, and to
Daks Rowney who
supplied the paper.

CONTENTS

THE COLORS

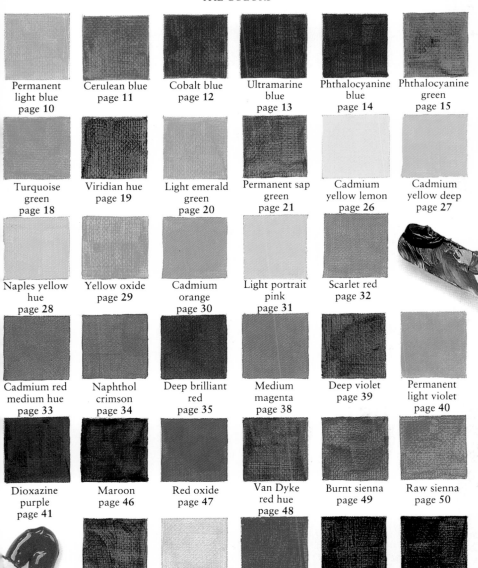

Permanent light blue page 10	Cerulean blue page 11	Cobalt blue page 12	Ultramarine blue page 13	Phthalocyanine blue page 14	Phthalocyanine green page 15
Turquoise green page 18	Viridian hue page 19	Light emerald green page 20	Permanent sap green page 21	Cadmium yellow lemon page 26	Cadmium yellow deep page 27
Naples yellow hue page 28	Yellow oxide page 29	Cadmium orange page 30	Light portrait pink page 31	Scarlet red page 32	
Cadmium red medium hue page 33	Naphthol crimson page 34	Deep brilliant red page 35	Medium magenta page 38	Deep violet page 39	Permanent light violet page 40
Dioxazine purple page 41	Maroon page 46	Red oxide page 47	Van Dyke red hue page 48	Burnt sienna page 49	Raw sienna page 50
	Raw umber page 51	Unbleached titanium page 54	Neutral gray value 5 page 55	Payne's gray page 56	Ivory black page 57

HOW TO USE THIS BOOK

THE AIM OF THIS BOOK is to give the artist an easy at-a-glance guide to over 2,000 acrylic color mixes, tint variations, and glazes. Beginners to painting are often confused by the science of color mixing, and it can take time, effort, and experimentation to arrive at satisfactory mixes. This book will take some of the trial and error out of the process, as well as revealing some surprising combinations. The mixtures shown here, however, should be seen only as a starting point. Each consists of only two colors, plus a proportion of white; by adding a third color or varying the amount of white, you can achieve almost unlimited permutations.

WHAT THE
SYMBOLS MEAN

 Opaque

 Transparent

 Translucent

 Permanent

 Normally
permanent

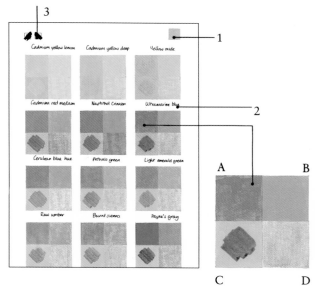

▲ Using the main charts
Each page features one of the 34 colors referred to as the "main" color (1). For a visual guide to these, see page 3. On each page, the main color is mixed with a constant basic palette color (2, and see opposite) in four different permutations: A) main color + basic palette color in a ratio of 60:40; B) swatch A + white in a ratio of 50:50; C) basic palette color overlaid onto main color; D) swatch A diluted with water. The symbols (3) denote various characteristics of the main color.

THE BASIC PALETTE

The basic palette of 12 colors chosen for the book provide a good spread and variety, but this is only a suggested list. If you have already established personal color preferences, you may wish to substitute other colors.

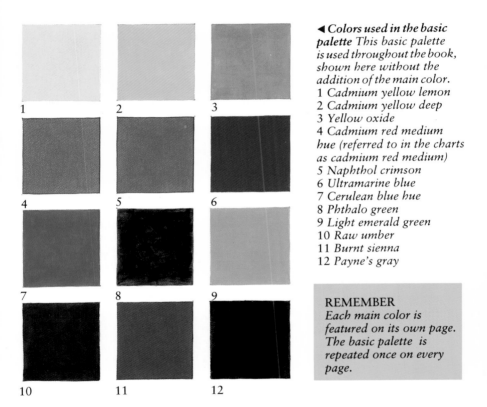

◄ *Colors used in the basic palette* This basic palette is used throughout the book, shown here without the addition of the main color.
1 *Cadmium yellow lemon*
2 *Cadmium yellow deep*
3 *Yellow oxide*
4 *Cadmium red medium hue (referred to in the charts as cadmium red medium)*
5 *Naphthol crimson*
6 *Ultramarine blue*
7 *Cerulean blue hue*
8 *Phthalo green*
9 *Light emerald green*
10 *Raw umber*
11 *Burnt sienna*
12 *Payne's gray*

REMEMBER
Each main color is featured on its own page. The basic palette is repeated once on every page.

A LIMITED PALETTE

Most professional artists work with a limited range of colors, having learned through experience the mixtures these are capable of producing. On pages 58–59, you will find a limited palette of eight colors including white, demonstrating the wide variety that can be produced by two-color mixtures in varying proportions.

UNDERSTANDING THE SPECIAL CHARTS

The five charts spread throughout this book show some suggested mixes for a variety of secondaries – greens, oranges, and purples – and some ideas for neutral colors – browns and grays.

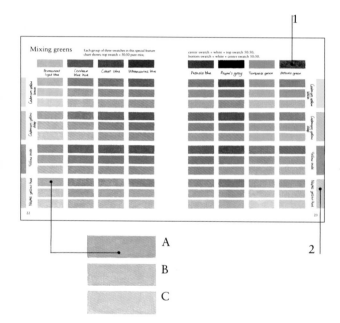

◄ *Using the special charts The color shown at the top of the page (1) is mixed with an equal amount of the one shown running down the edge of the page (2). The resulting color is the top swatch in each block of three (A). The second swatch (B) shows swatch "A" mixed with an equal amount of white; and for the third swatch (C), swatch "B" has again been mixed with white in equal proportions.*

ABOUT ACRYLICS

When acrylic was first on the market, it mainly found favor with experimental artists, but those working in the so-called traditional styles are now increasingly turning to the medium. Because acrylic is relatively new, it lacks the time-hallowed body of techniques associated with oil paints, tempera, or watercolors, and artists are still in the process of building a technical vocabulary, while manufacturers are continually inventing new mediums and additives.

A mistake often made by newcomers to acrylic is to use it as a substitute for oil or watercolor. The best results will come from realizing that acrylic has its own properties that makes it very different from either.

PRIMARY, SECONDARY, AND TERTIARY COLORS

The three primary colors, so-called because they cannot be mixed from other colors, are red, yellow, and blue. A mixture of two primaries produces a secondary color: red and blue make purple; blue and yellow make green; yellow and red make orange. But there are many different reds, yellows, and blues; and the secondary color obtained will depend on which ones are used. The tertiary colors are mixtures of three colors, that is, one primary and one secondary.

▶▼ Creating secondaries
Pure secondaries are obtained by mixing primaries that show a bias towards one another on the color wheel. Subdued secondaries are created by mixing primaries that are farther apart on the color wheel.

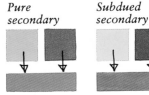

Pure secondary	Subdued secondary

▶ Mixing tertiaries *The tertiary colors are those that fall between the primaries and the secondaries. They are made by mixing equal amounts of a primary and the secondary next to it. The colors are red-orange, yellow-orange, yellow-green, blue-green, blue-violet, and red-violet.*

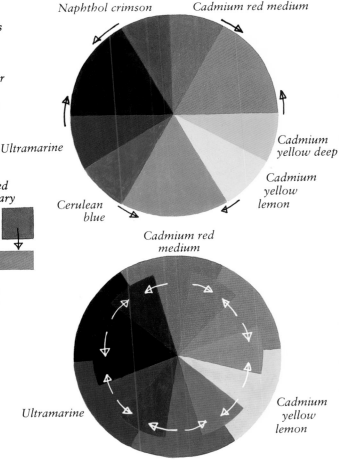

Naphthol crimson

Cadmium red medium

Ultramarine

Cadmium yellow deep

Cadmium yellow lemon

Cerulean blue

Cadmium red medium

Ultramarine

Cadmium yellow lemon

7

COMPLEMENTARY COLORS

Complementary colors are those that are opposite each other on the color wheel: orange and blue; red and green; violet and yellow. Good use can be made of these in painting. When juxtaposed, complentary colors create vibrant contrasts, while a color that looks too loud or bright can be "knocked back," or neutralized, by mixing in a little of its complementary. Another point to remember is that mixtures of complementary colors will produce a whole range of neutral grays and browns.

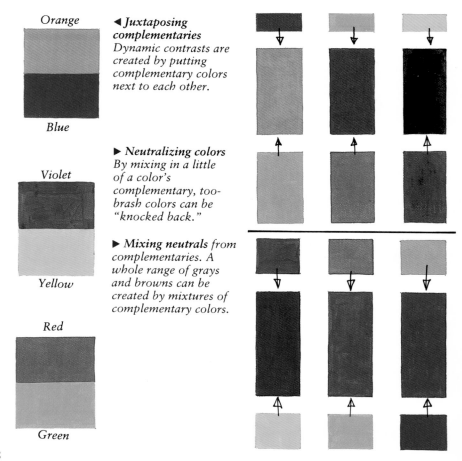

Orange

Blue

◄ Juxtaposing complementaries
Dynamic contrasts are created by putting complementary colors next to each other.

Violet

Yellow

► Neutralizing colors
By mixing in a little of a color's complementary, too-brash colors can be "knocked back."

► Mixing neutrals *from complementaries. A whole range of grays and browns can be created by mixtures of complementary colors.*

Red

Green

PAINT AND MEDIUMS

Acrylic mixed with water alone dries to a semi-matte finish, but there are many different mediums which alter the appearance, character, and performance of the paint. These can make it more glossy, more transparent or opaque, and also improve the flow or retard drying time. Some have an effect on the color, increasing its brilliance. These mediums, some of which are used in the manufacture of the paint, appear white in the jar but dry clear, so that the colors become slightly darker. This characteristic of acrylic paint can take some getting used to, especially when trying to match a color. The effect is most noticeable in lighter colors or those with white added. Glazing medium added to the paint increases its transparency, making it possible to lay light veils of color over previously painted colors. As each new color modifies or enriches those below, the method achieves an intensity that is hard to obtain in other ways.

▶ *Mixing acrylic and different media* The appearance of the color will vary according to how much of the medium is used. The top row is pure color straight from the tube. The next row shows the color mixed with 20% medium; beneath that the color has 40% medium added; the bottom row shows the color with 60% medium.

When mixed with water, the paint dries matt and loses some of its intensity. Gloss or glazing medium gives a crisper, brighter finish, while mixing in white changes the color and increases its opacity.

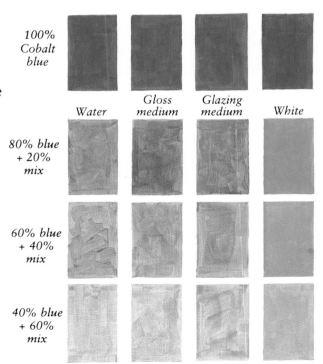

100% Cobalt blue

Water

Gloss medium

Glazing medium

White

80% blue + 20% mix

60% blue + 40% mix

40% blue + 60% mix

 # Permanent light blue

Cadmium yellow lemon

Cadmium yellow deep

Yellow oxide

Cadmium red medium

Naphthol Crimson

Ultramarine blue

Cerulean blue hue

Phthalo green

Light emerald green

Raw umber

Burnt sienna
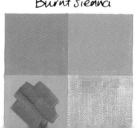

Payne's gray
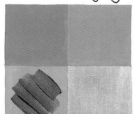

Cadmium yellow lemon
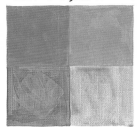

Cadmium yellow deep
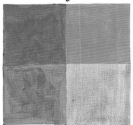

Yellow oxide
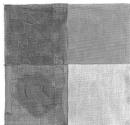

Cadmium red medium
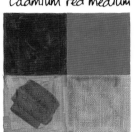

Naphthol Crimson
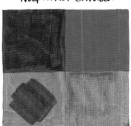

Ultramarine blue
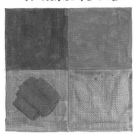

Cerulean blue hue
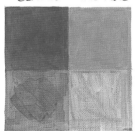

Phthalo green
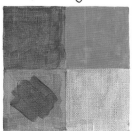

Light emerald green
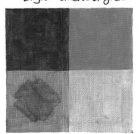

Raw umber
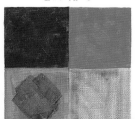

Burnt sienna
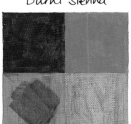

Payne's gray
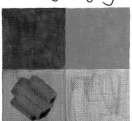

 # Cobalt blue

Cadmium yellow lemon
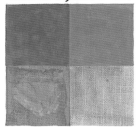

Cadmium yellow deep
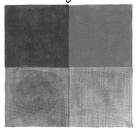

Yellow oxide
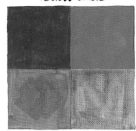

Cadmium red medium
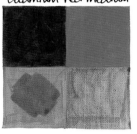

Naphthol Crimson
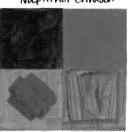

Ultramarine blue
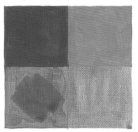

Cerulean blue hue
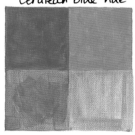

Phthalo green
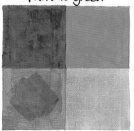

Light emerald green
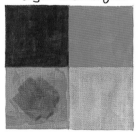

Raw umber
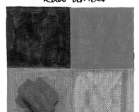

Burnt sienna

Payne's gray

Cadmium yellow lemon
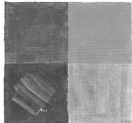

Cadmium yellow deep
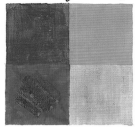

Yellow oxide
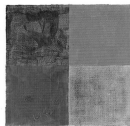

Cadmium red medium
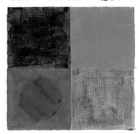

Naphthol Crimson
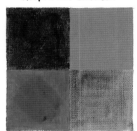

Ultramarine blue
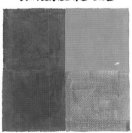

Cerulean blue hue
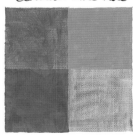

Phthalo green
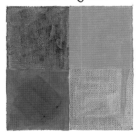

Light emerald green

Raw umber

Burnt sienna

Payne's gray

 # Phthalo blue

Cadmium yellow lemon

Cadmium yellow deep

Yellow oxide

Cadmium red medium

Naphthol Crimson

Ultramarine blue

Cerulean blue hue
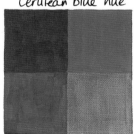

Phthalo green
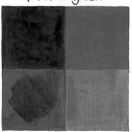

Light emerald green
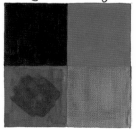

Raw umber
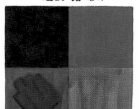

Burnt sienna

Payne's gray

Phthalo green

Cadmium yellow lemon

Cadmium yellow deep

Yellow oxide

Cadmium red medium

Naphthol Crimson

Ultramarine blue

Cerulean blue hue

Phthalo green

Light emerald green

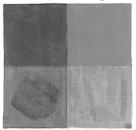

Raw umber

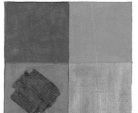

Burnt sienna

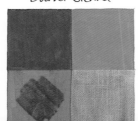

Payne's gray

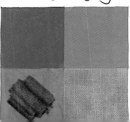

WATERCOLOR TECHNIQUES

Roy Sparkes – *Late Autumn, Near Cliffe, Kent*

8 x 10 inches

USED THINLY, ACRYLIC behaves very much like watercolor or gouache; the main difference is that acrylics are not water-soluble when they dry. This cool winter landscape is an on-the-spot sketch painted on cardboard. The artist begins by recording impressions in several small pictures, which he works up later in the studio.

▶ *Phthalocyanine blue is applied diluted with water in thin washes, with clear water dropped into the pigment to create cloud-like watermarks.*

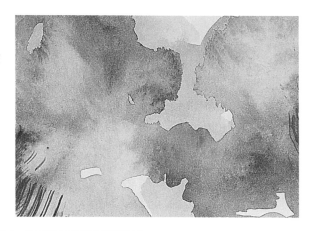

◀ *Thin washes of the same blue are used to suggest distant hills, and the blue is then mixed with cadmium yellow lemon to make a cool green. As we approach the middle distance, the addition of burnt umber warms the color slightly. In the field, very thin blue has been painted over a watery wash of lemon yellow.*

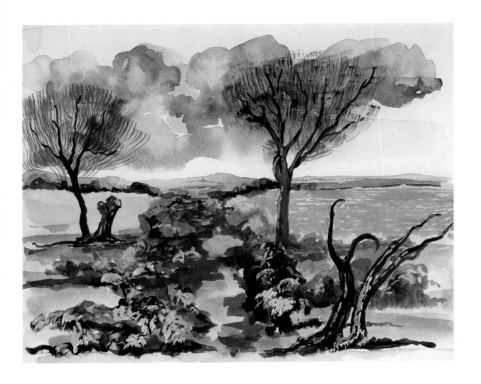

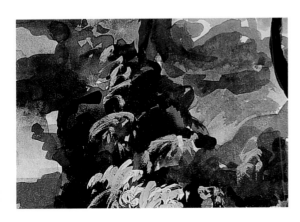

◀ *In the foreground, mixtures of viridian hue, phthalocyanine blue, and lemon yellow together with burnt umber make up the hedges along side the track. Flecks of white and cadmium yellow suggest highlights on the foliage.*

Turquoise green

Cadmium yellow lemon

Cadmium yellow deep

Yellow oxide
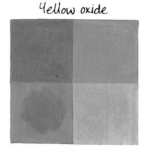

Cadmium red medium
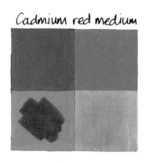

Naphthol Crimson
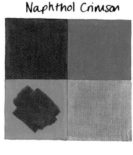

Ultramarine blue
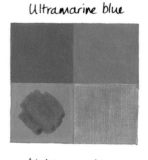

Cerulean blue hue
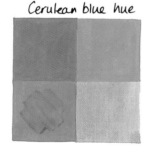

Phthalo green
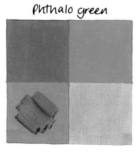

Light emerald green
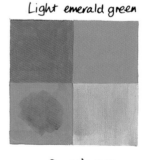

Raw umber
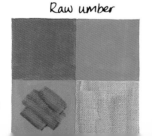

Burnt sienna
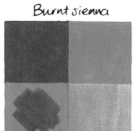

Payne's gray
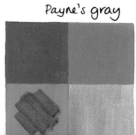

Cadmium yellow lemon

Cadmium yellow deep

Yellow oxide
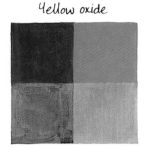

Cadmium red medium
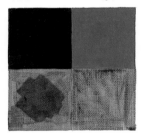

Naphthol Crimson
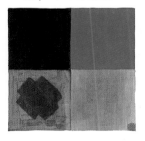

Ultramarine blue
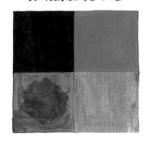

Cerulean blue hue
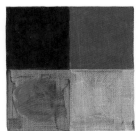

Phthalo green
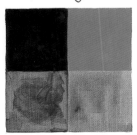

Light emerald green
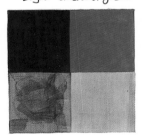

Raw umber
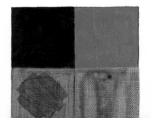

Burnt sienna
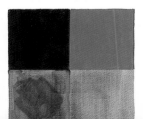

Payne's gray

 # Light emerald green

Cadmium yellow lemon
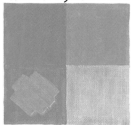

Cadmium yellow deep
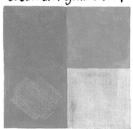

Yellow oxide
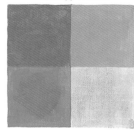

Cadmium red medium
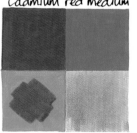

Naphthol Crimson
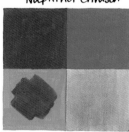

Ultramarine blue
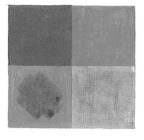

Cerulean blue hue
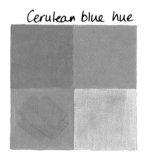

Phthalo green
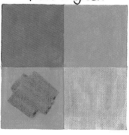

Light emerald green
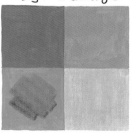

Raw umber

Burnt sienna

Payne's gray

Permanent sap green

Cadmium yellow lemon
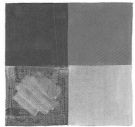

Cadmium yellow deep
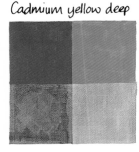

Yellow oxide
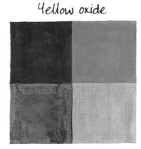

Cadmium red medium
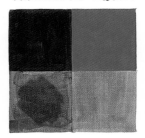

Naphthol Crimson
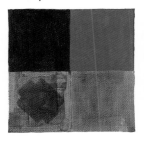

Ultramarine blue
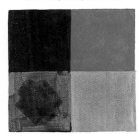

Cerulean blue hue
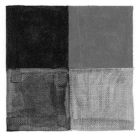

Phthalo green
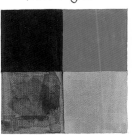

Light emerald green
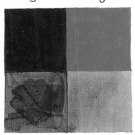

Raw umber
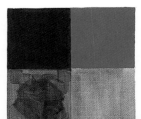

Burnt sienna
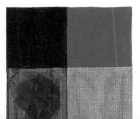

Payne's gray

21

Mixing greens

Each group of three swatches in this special feature chart shows: top swatch = 50:50 pure mix;

	Permanent light blue	Cerulean blue hue	Cobalt blue	Ultramarine blue
Cadmium yellow lemon				
Cadmium yellow deep				
Yellow oxide				
Naples yellow hue				

center swatch = white + top swatch 50:50;
bottom swatch = white + center swatch 50:50.

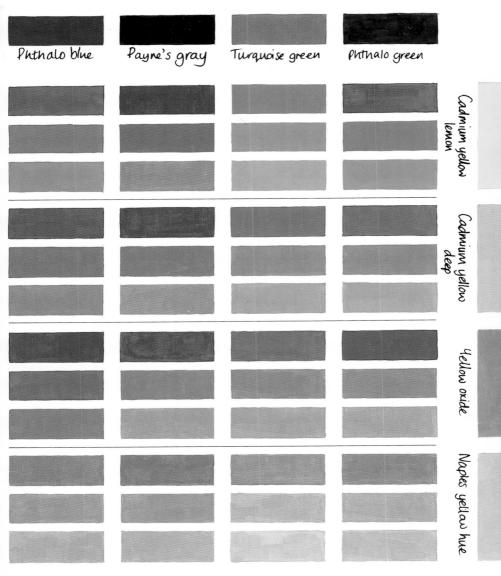

Phthalo blue Payne's gray Turquoise green Phthalo green

Cadmium yellow lemon

Cadmium yellow deep

Yellow oxide

Naples yellow hue

For further information, turn to page 6.

USING GREENS AND BROWNS

Richard J. Smith – *Little Ringed Plover at Nest*

17¾ x 27½inches

THE PAINTING ON GESSOED and colored masoniter, while not employing a large range of greens or browns, shows how a highly successful picture can be achieved using a limited palette. The artist first covered the board loosely with red oxide and raw umber, out of which the painting was worked. This technique of toning the ground is called *imprimatura*, and the ground color is often used as a medium tone in the painting.

► *The plover's plumage has been painted with the same range of colors as those used in the background, giving the bird its camouflage.*

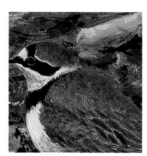

▼ *When the painting was nearing completion, the artist glazed over the whole surface with green. The lighter, cleaner color on the bird, rocks, and stones and the light reflection in the water were added after this, together with the final details.*

▲ *Ultramarine blue and yellow ocher lightened with titanium white form the basis for the green used throughout. The paint is applied opaquely, using direct brushstrokes suggesting the sparse grass.*

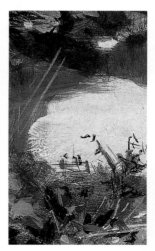

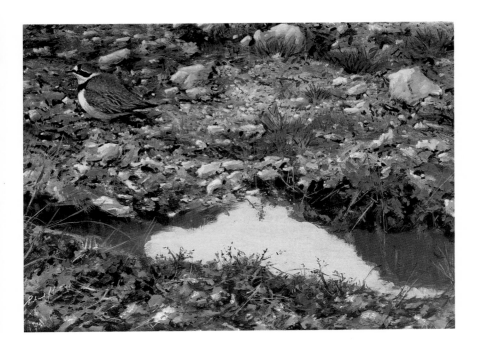

◀ *The ground color is allowed to show through, giving the impression that detailed painting has taken place, while in fact it has not.*

Cadmium yellow lemon

Cadmium yellow lemon	Cadmium yellow deep	Yellow oxide
	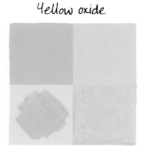	

Cadmium red medium	Naphthol Crimson	Ultramarine blue
	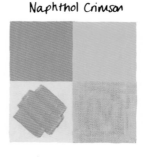	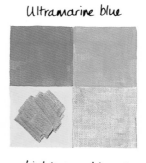

Cerulean blue hue	Phthalo green	Light emerald green
	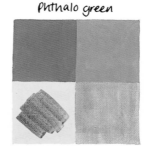	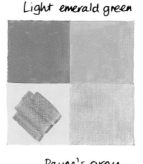

Raw umber	Burnt sienna	Payne's gray
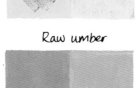	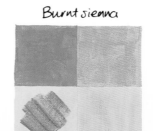	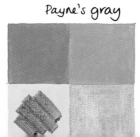

Cadmium yellow deep

Cadmium yellow lemon

Cadmium yellow deep

Yellow oxide

Cadmium red medium

Naphthol Crimson

Ultramarine blue

Cerulean blue hue
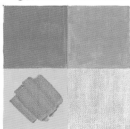

Phthalo green
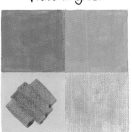

Light emerald green
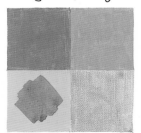

Raw umber

Burnt sienna

Payne's gray

27

Naples yellow hue

Cadmium yellow lemon

Cadmium yellow deep

Yellow oxide

Cadmium red medium

Naphthol Crimson

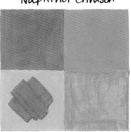

Ultramarine blue

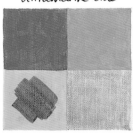

Cerulean blue hue

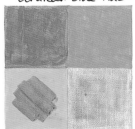

Phthalo green

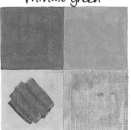

Light emerald green

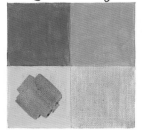

Raw umber

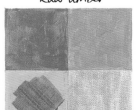

Burnt sienna

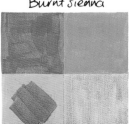

Payne's gray

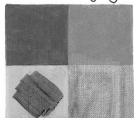

Yellow oxide

Cadmium yellow lemon

Cadmium yellow deep

Yellow oxide

Cadmium red medium

Naphthol Crimson

Ultramarine blue

Cerulean blue hue

Phthalo green

Light emerald green

Raw umber

Burnt sienna
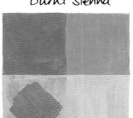

Payne's gray
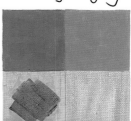

 # Cadmium orange

Cadmium yellow lemon

Cadmium yellow deep

Yellow oxide

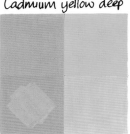

Cadmium red medium

Naphthol Crimson

Ultramarine blue

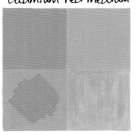
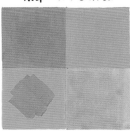
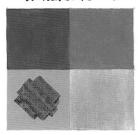

Cerulean blue hue

Phthalo green

Light emerald green

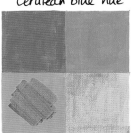
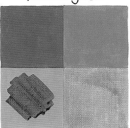
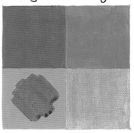

Raw umber

Burnt sienna

Payne's gray

Light portrait pink

Cadmium yellow lemon

Cadmium yellow deep

Yellow oxide

Cadmium red medium

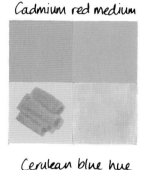

Naphthol Crimson

Ultramarine blue

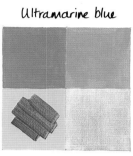

Cerulean blue hue

Phthalo green

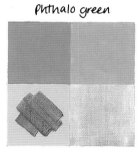

Light emerald green

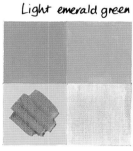

Raw umber

Burnt sienna

Payne's gray

31

 # Scarlet red

Cadmium yellow lemon
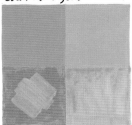

Cadmium yellow deep
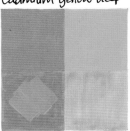

Yellow oxide
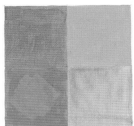

Cadmium red medium
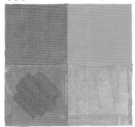

Naphthol Crimson
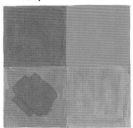

Ultramarine blue
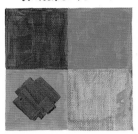

Cerulean blue hue
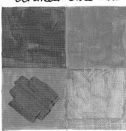

Phthalo green
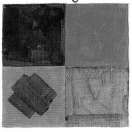

Light emerald green
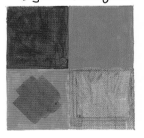

Raw umber
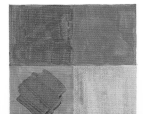

Burnt sienna
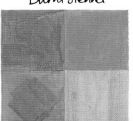

Payne's gray
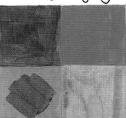

Cadmium red medium

Cadmium yellow lemon
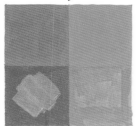

Cadmium yellow deep

Yellow oxide

Cadmium red medium

Naphthol Crimson

Ultramarine blue
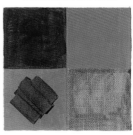

Cerulean blue hue
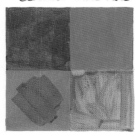

Phthalo green
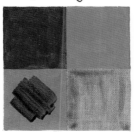

Light emerald green
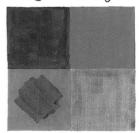

Raw umber
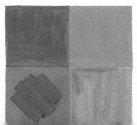

Burnt sienna
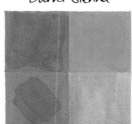

Payne's gray
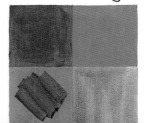

33

 # Naphthol crimson

Cadmium yellow lemon
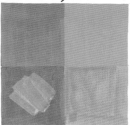

Cadmium yellow deep
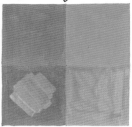

Yellow oxide
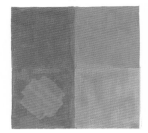

Cadmium red medium

Naphthol Crimson

Ultramarine blue

Cerulean blue hue

Phthalo green

Light emerald green

Raw umber

Burnt sienna

Payne's gray

Cadmium yellow lemon

Cadmium yellow deep
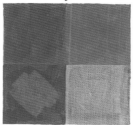

Yellow oxide
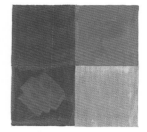

Cadmium red medium
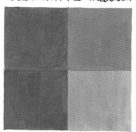

Naphthol Crimson

Ultramarine blue
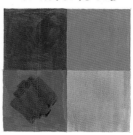

Cerulean blue hue
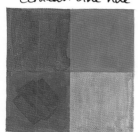

Phthalo green
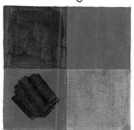

Light emerald green
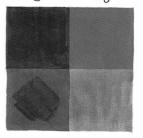

Raw umber
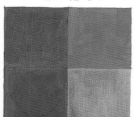

Burnt sienna

Payne's gray
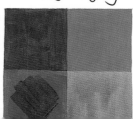

A DIRECT APPROACH

Gerry Baptist – *Pines in a Clandon Garden*

23½ x 33inches

THIS BRIGHT, ENERGETIC PAINTING reminiscent of early Matisse and the Fauve painters shows paint being used in a very instinctive and urgent manner. But there is nothing arbitrary about the colors used; all are carefully considered, and the work has a jewel-like quality. The artist works on location using bristle brushes, water, and a retarding medium to slow down the drying time.

▶ *All colors are carefully mixed on the palette before being applied, and in places layers of paint are allowed to build up. Here, lemon and cadmium yellows along with bright mauves and touches of bright green create a rich, warm foreground.*

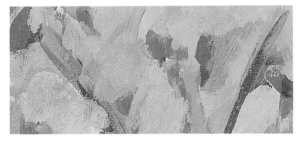

◀ *The colors cool slightly toward the middle distance. Viridian and mixes of ultramarine and cerulean blue create the foliage of the central tree. No black is used, as it could deaden the color.*

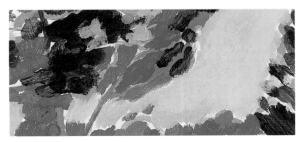

◀ *The sky consists of a mix of cerulean blue and titanium white with a touch of yellow applied around the foliage to redefine the shape of the trees.*

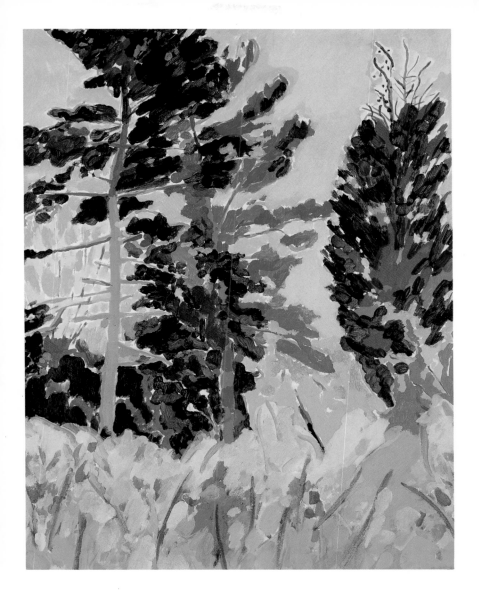

 # Medium magenta

Cadmium yellow lemon

Cadmium yellow deep

Yellow oxide
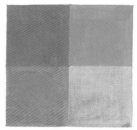

Cadmium red medium
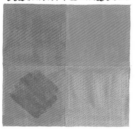

Naphthol Crimson
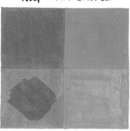

Ultramarine blue
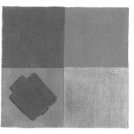

Cerulean blue hue
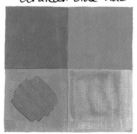

Phthalo green
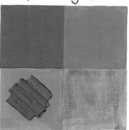

Light emerald green
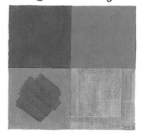

Raw umber

Burnt sienna

Payne's gray
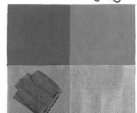

Cadmium yellow lemon

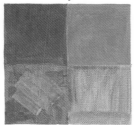

Cadmium yellow deep

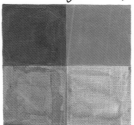

Yellow oxide

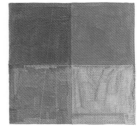

Cadmium red medium

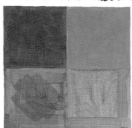

Naphthol Crimson

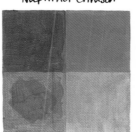

Ultramarine blue

Cerulean blue hue

Phthalo green

Light emerald green

Raw umber

Burnt sienna

Payne's gray

39

Permanent light violet

Cadmium yellow lemon
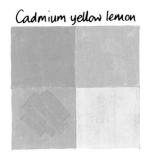

Cadmium yellow deep
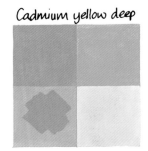

Yellow oxide
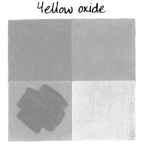

Cadmium red medium
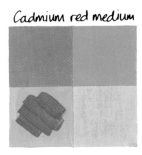

Naphthol Crimson
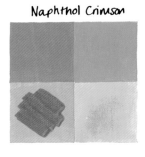

Ultramarine blue
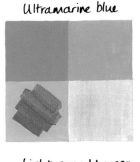

Cerulean blue hue
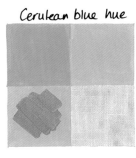

Phthalo green
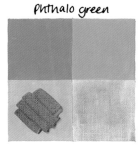

Light emerald green
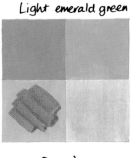

Raw umber
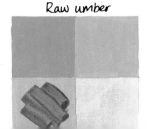

Burnt sienna
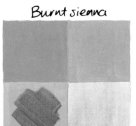

Payne's gray
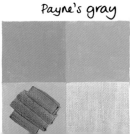

Dioxazine purple

Cadmium yellow lemon
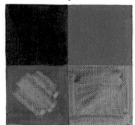

Cadmium yellow deep
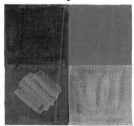

Yellow oxide
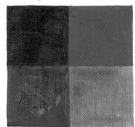

Cadmium red medium
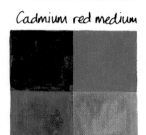

Naphthol Crimson
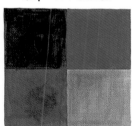

Ultramarine blue
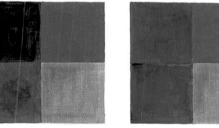

Cerulean blue hue
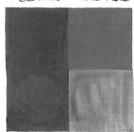

Phthalo green
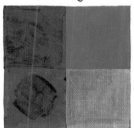

Light emerald green
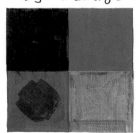

Raw umber

Burnt sienna

Payne's gray

Mixing oranges

Each group of three swatches in these special feature charts shows: top swatch = 50:50 pure mix;

	Cadmium yellow lemon	Cadmium yellow deep	Yellow oxide	Naples yellow hue
Scarlet red				
Cadmium red medium				
Naphthol Crimson				
Deep brilliant red				

center swatch = white + top swatch 50:50;
bottom swatch = white + center swatch 50:50.

Mixing purples

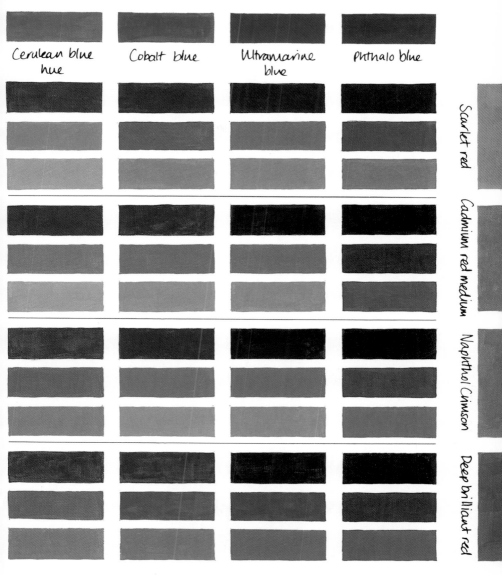

Cerulean blue hue

Cobalt blue

Ultramarine blue

Phthalo blue

Scarlet red

Cadmium red medium

Naphthol Crimson

Deep brilliant red

For further information, turn to page 6.

USING YELLOWS AND PURPLES

Paul Powis – *The Malverns*

4 x 4 feet

THE ARTIST'S APPROACH and method of execution are both very interesting. After working out a series of small sketches, he begins the painting itself on plywood that has been given a gloss black ground. The shapes and elements are drawn onto this in bright pastel. The artist tends to work flat with the board horizontal rather than at the easel.

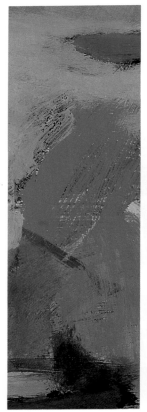

◀ *The paint mixed with water is worked wet into wet, using very direct and immediate brush strokes.*

▼ *Using large brushes, the artist paints the complementary of the color he wants to end up with. In this case, he wants a purple, so the underpainting is done in its complementary, orange.*

◀ *Working initially into the black ground, the colors are mixed very carefully until the tonal values are correct.*

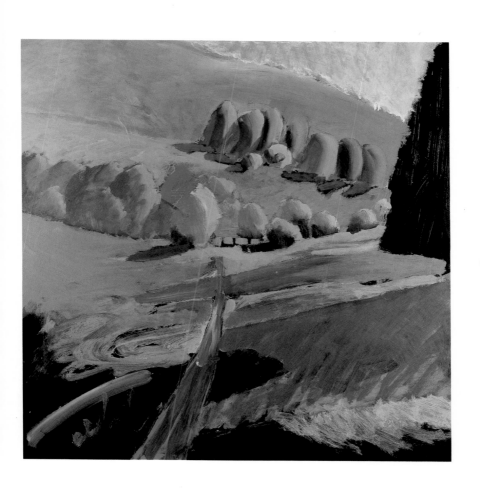

 # Maroon

Cadmium yellow lemon

Cadmium yellow deep

Yellow oxide

Cadmium red medium

Naphthol Crimson

Ultramarine blue

Cerulean blue hue
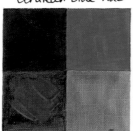

Phthalo green
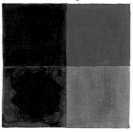

Light emerald green
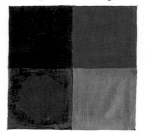

Raw umber
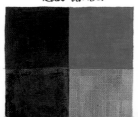

Burnt sienna

Payne's gray

Red oxide

Cadmium yellow lemon

Cadmium yellow deep

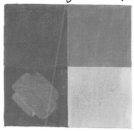

Yellow oxide

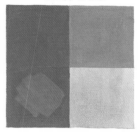

Cadmium red medium

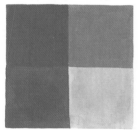

Naphthol Crimson

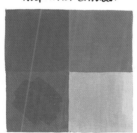

Ultramarine blue

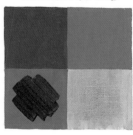

Cerulean blue hue

Phthalo green

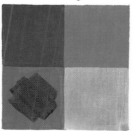

Light emerald green

Raw umber

Burnt sienna

Payne's gray

 # Van dyke red hue

Cadmium yellow lemon
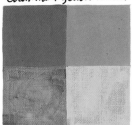

Cadmium yellow deep
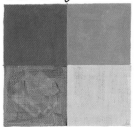

Yellow oxide
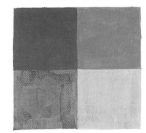

Cadmium red medium
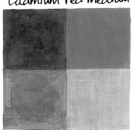

Naphthol Crimson
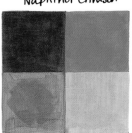

Ultramarine blue
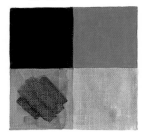

Cerulean blue hue
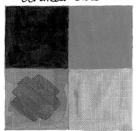

Phthalo green

Light emerald green

Raw umber

Burnt sienna

Payne's gray
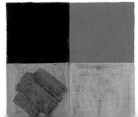

Cadmium yellow lemon
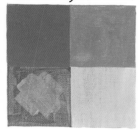

Cadmium yellow deep
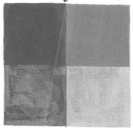

Yellow oxide
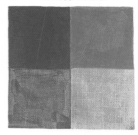

Cadmium red medium
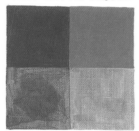

Naphthol Crimson
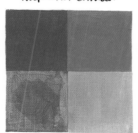

Ultramarine blue
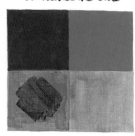

Cerulean blue hue
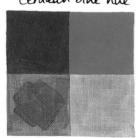

Phthalo green
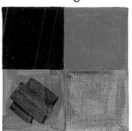

Light emerald green
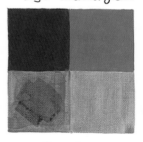

Raw umber
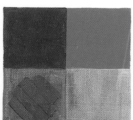

Burnt sienna
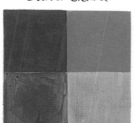

Payne's gray
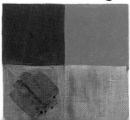

 # Raw sienna

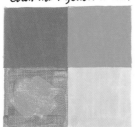
Cadmium yellow lemon

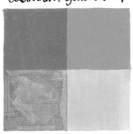
Cadmium yellow deep

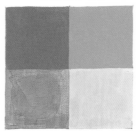
Yellow oxide

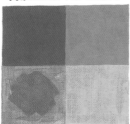
Cadmium red medium

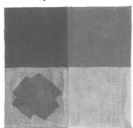
Naphthol Crimson

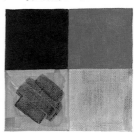
Ultramarine blue

Cerulean blue hue

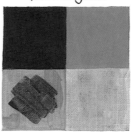
Phthalo green

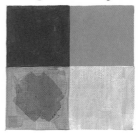
Light emerald green

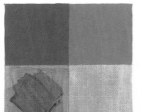
Raw umber

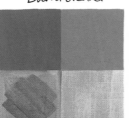
Burnt sienna

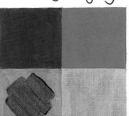
Payne's gray

Raw umber

Cadmium yellow lemon

Cadmium yellow deep

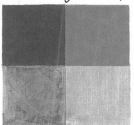

Yellow oxide

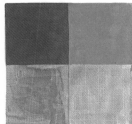

Cadmium red medium

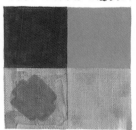

Naphthol Crimson

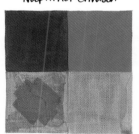

Ultramarine blue

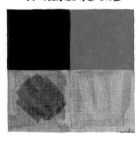

Cerulean blue hue

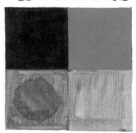

Phthalo green

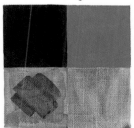

Light emerald green

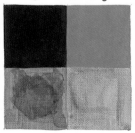

Raw umber

Burnt sienna

Payne's gray

Mixing browns

Each group of three swatches in these special feature charts shows: top swatch = 50:50 pure mix.

	Light emerald green	Permanent sap green	Viridian hue	Raw umber
Scarlet red				
Cadmium red medium				
Naphthol Crimson				
Deep brilliant red				

center swatch = white + top swatch 50:50;
bottom swatch = white + center swatch 50:50.

Mixing grays

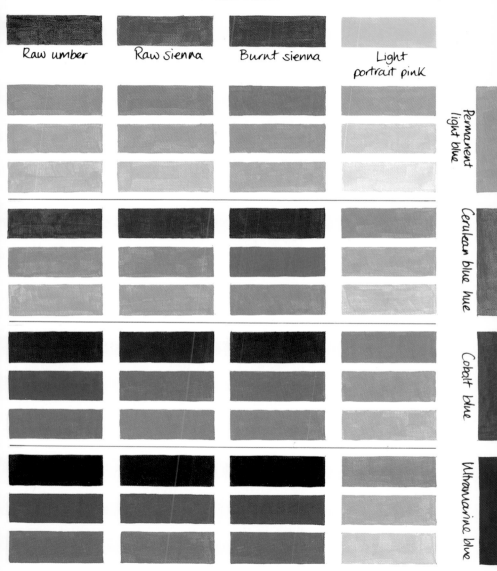

Raw umber

Raw sienna

Burnt sienna

Light
portrait pink

Permanent
light blue

Cerulean blue hue

Cobalt blue

Ultramarine blue

For further information, turn to page 6.

Unbleached titanium

Cadmium yellow lemon

Cadmium yellow deep

Yellow oxide

Cadmium red medium

Naphthol Crimson

Ultramarine blue

Cerulean blue hue

Phthalo green

Light emerald green

Raw umber

Burnt sienna
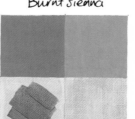

Payne's gray
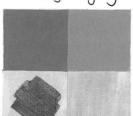

Neutral gray value 5

Cadmium yellow lemon
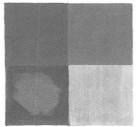

Cadmium yellow deep
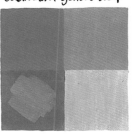

Yellow oxide
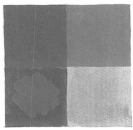

Cadmium red medium
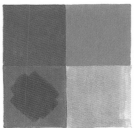

Naphthol Crimson
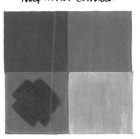

Ultramarine blue
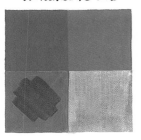

Cerulean blue hue
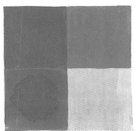

Phthalo green
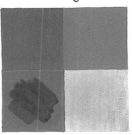

Light emerald green
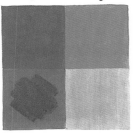

Raw umber
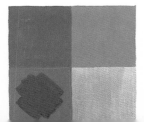

Burnt sienna
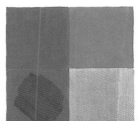

Payne's gray
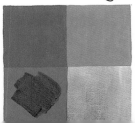

 # Payne's gray

Cadmium yellow lemon

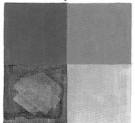

Cadmium yellow deep

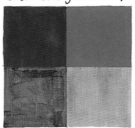

Yellow oxide

Cadmium red medium

Naphthol Crimson

Ultramarine blue

Cerulean blue hue

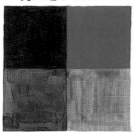

Phthalo green

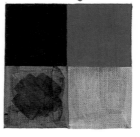

Light emerald green

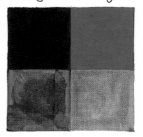

Raw umber

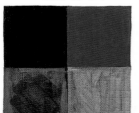

Burnt sienna

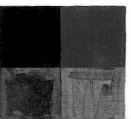

Payne's gray

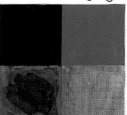

Ivory black

Cadmium yellow lemon
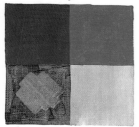

Cadmium yellow deep

Yellow oxide

Cadmium red medium

Naphthol Crimson

Ultramarine blue
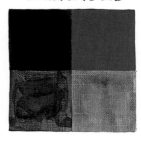

Cerulean blue hue
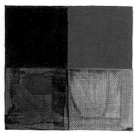

Phthalo green
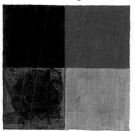

Light emerald green
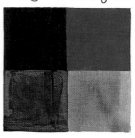

Raw umber

Burnt sienna

Payne's gray

Using a limited palette

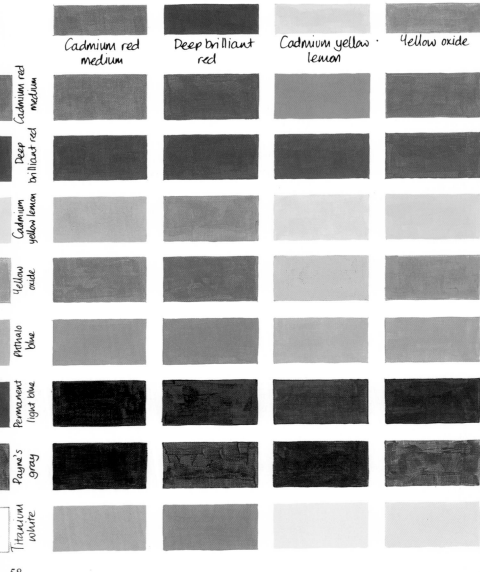

	Cadmium red medium	Deep brilliant red	Cadmium yellow lemon	Yellow oxide
Cadmium red medium				
Deep brilliant red				
Cadmium yellow lemon				
Yellow oxide				
Phthalo blue				
Permanent light blue				
Payne's gray				
Titanium white				

The special chart below shows how a limited palette of only 8 colors can be extended by mixing the horizontal band of swatches with the vertical band of swatches in a ratio of 20:80.

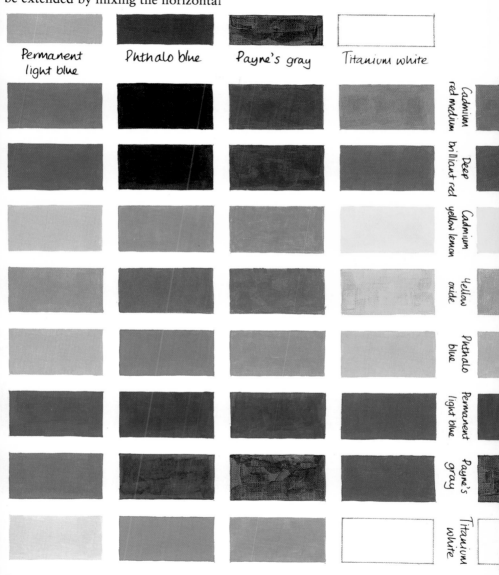

	Permanent light blue	Phthalo blue	Payne's gray	Titanium white
Cadmium red medium				
Deep brilliant red				
Cadmium yellow lemon				
Yellow oxide				
Phthalo blue				
Permanent light blue				
Payne's gray				
Titanium white				

Glazing

A glaze is a transparent layer of paint applied over another color so that it tints and modifies the underlayer. Any number of glazes can be superimposed as long as each is allowed to dry before painting the next. Glazing was originally an oil-painting technique, but it is ideal for fast-drying acrylics, and the effects are quite unlike those achieved with opaque mixtures.

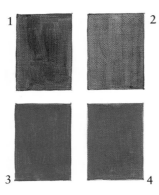

Mixing and glazing – comparing the effects
1) *deep violet mixed with cadmium yellow lemon;*
2) *cadmium yellow lemon glazed over deep violet;* 3) *medium magenta mixed with light emerald green;* 4) *light emerald green glazed over medium magenta.*

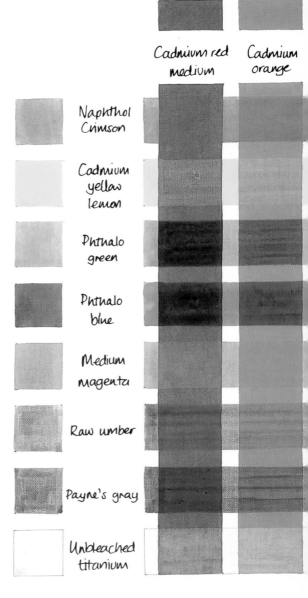

Cadmium red medium Cadmium orange

Naphthol Crimson

Cadmium yellow lemon

Phthalo green

Phthalo blue

Medium magenta

Raw umber

Payne's gray

Unbleached titanium

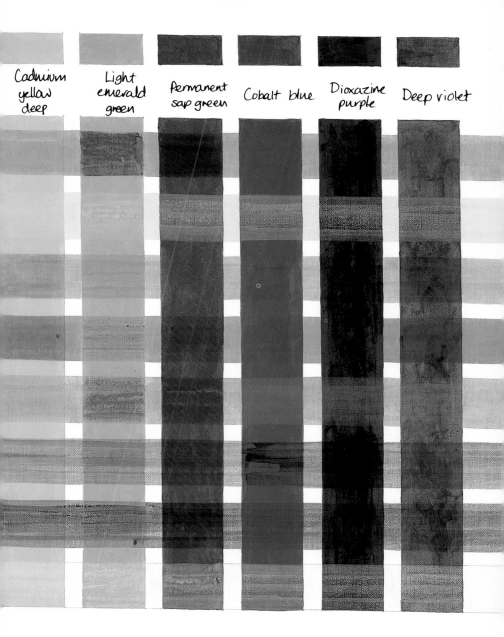

Cadmium yellow deep

Light emerald green

Permanent sap green

Cobalt blue

Dioxazine purple

Deep violet

61

USING GLAZES

Ian Sidaway – *The Sphinx, the Pyramids and Alice at Giza*

20 x 20ins

THIS PAINTING ON A GESSOED board shows the depth and intensity of color that can be achieved by glazing. A detailed pencil drawing was made before washing over the board with a yellow oxide and white mix. The landscape was developed with orange and purple washes, allowing each previous layer to show through, and the figure of the girl was worked in much the same way, but with more layers of thicker paint to give her solidity.

▼ *The texture of rock and sand was achieved by loosely scrubbing thin paint on with a bristle brush. This causes the paint to froth; when dry, the shape of the bubbles are visible, with subsequent layers exaggerating the effect. A cadmium yellow and naphthol crimson mix make up the base color for the rocks, with naphthol crimson and cobalt blue added by degrees for the areas in shadow.*

▲ *The darker hair was painted first with a mix of yellow ocher, Payne's gray, and titanium white. When the hair was dry, masking tape was put onto the area and the light wisps of hair cut out; these were then painted with a mixture of cadmium yellow and titanium white.*

◄ *The purple of the pyramids consists of Payne's gray, naphthol crimson, and titanium white. Although the color scheme is essentially warm, the coolness here helps to suggest distance.*

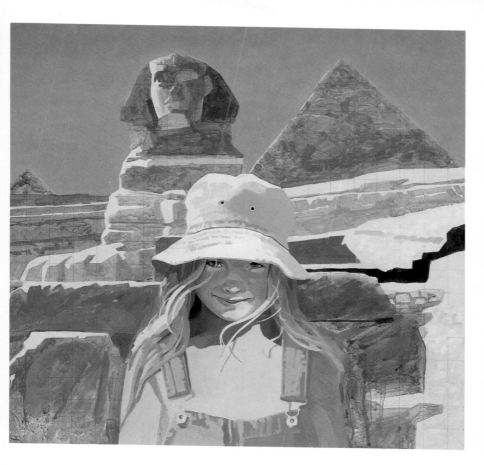

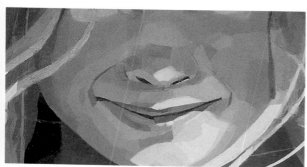

◀ *The skin tones were obtained by using the same combination of colors used on the rocks with the addition of yellow oxide and white for the highlights.*

Equivalent Colors

Liquitex	Rowney	Winsor & Newton
Permanent light blue	No equivalent	No equivalent
Cerulean blue	Coeruleum	Cerulean blue
Cobalt blue	Cobalt blue	Cobalt blue
Ultramarine blue	Ultramarine	Ultramarine blue
Phthalo-cyanine blue	Indanthrene blue	Prussian blue hue
Phthalo-cyanine green	Monestial green	Phthalo-cyanine green
Turquoise green	Monestial turquoise	Turquoise green
Viridian hue	No equivalent	No equivalent
Light emerald green	No equivalent	No equivalent
Permanent sap green	Bright green	Sap green
Cadmium yellow lemon	Lemon yellow	Lemon yellow
Cadmium yellow deep	Cadmium yellow deep	Cadmium yellow deep
Naples yellow hue	Naples yellow	Naples yellow
Yellow oxide	Yellow ocher	Yellow ocher
Cadmium orange	Cadmium orange	Cadmium orange
Light portrait pink	Flesh tint	Light portrait pink
Scarlet red	Cadmium scarlet	Cadmium red light

Liquitex	Rowney	Winsor & Newton
Cadmium red medium hue	Cadmium red	Cadmium red medium
Naphthol crimson	Crimson	Naphthol crimson
Deep brilliant red	No equivalent	Deep brilliant red
Medium magenta	No equivalent	Medium magenta
Deep violet	Permanent violet	Prism violet
Permanent light violet	No equivalent	No equivalent
Dioxazine purple	Deep violet	Dioxazine purple
Maroon	No equivalent	No equivalent
Red dioxide	Venetian red	Red iron oxide
Van Dyke red hue	No equivalent	No equivalent
Burnt sienna	Burnt sienna	Burnt sienna
Raw sienna	Raw sienna	Raw sienna
Raw umber	Raw umber	Raw umber
Unbleached titanium	No equivalent	Unbleached titanium
Neutral gray value 5	Middle gray	Neutral gray
Payne's gray	Payne's gray	Payne's gray
Ivory black	Ivory black	Ivory black